Portraits in Fiction

Portraits in Fiction

A.S. Byatt

Based on the Heywood Hill Annual Lecture 2000,
The National Portrait Gallery, London

Chatto & Windus
LONDON

Published by Chatto & Windus 2001

2 4 6 8 10 9 7 5 3

First published in Great Britain in 2001 by
Chatto & Windus
Random House, 20 Vauxhall Bridge Road,
London SW1V 2SA

Random House Australia (Pty) Limited
20 Alfred Street, Milsons Point, Sydney,
New South Wales 2061, Australia

Random House New Zealand Limited
18 Poland Road, Glenfield,
Auckland 10, New Zealand

Random House (Pty) Limited
Endulini, 5A Jubilee Road, Parktown 2193, South Africa

The Random House Group Limited Reg. No. 954009
www.randomhouse.co.uk

A CIP catalogue record for this book
is available from the British Library

ISBN 07011 73106

Papers used by Random House are natural, recyclable products made from wood
grown in sustainable forests; the manufacturing processes conform to the
environmental regulations of the country of origin

Typeset in Fournier Monotype TC by SX Composing DTP, Rayleigh, Essex
Printed and bound in Great Britain by
Clays Ltd, St. Ives PLC

Contents

Illustrations

Colour Plates I

Black and White Plates

Portraits in Fiction

Portraits in words and portraits in paint are opposites, rather than metaphors for each other. A painted portrait is an artist's record, construction, of a physical presence, with a skin of colour, a layer of strokes of the brush, or the point, or the pencil, on a flat surface. A painting exists outside time and records the time of its making. It is in an important sense arrested and superficial – the word is not used in a derogatory way. The onlooker – as we shall see – may construct a relation in time with the painter, the sitter and the recorded face, but this is a more arbitrary, less consequential time than the end-to-end reading of a book. A portrait in a novel or a story may be a portrait of invisible things – thought processes, attractions, repulsions, subtle or violent changes in whole lives, or groups of lives. Even the description in visual language of a face or body may depend on being unseen for its force. I like to say, when talking about writing, 'Imagine a woman in a chair. Now imagine

1

that she is about thirty and dark. Now imagine that she is plump, in a green velvet dress, with her breasts showing above a décolleté neckline. Now give her big brown eyes, long lashes and a necklace of emeralds. Make the chair Gothic and put a burgundy-coloured curtain behind.' Everyone who goes through this process will have a more and more precise visual image. They will resemble each other, but, I guess, not much. Everyone sees their own woman. Put in an emotional word – 'sulky', 'voluptuous', 'gentle', 'mean' – and there will be even more variants. Writers rely on the endlessly varying visual images of individual readers and on the constructive visualising work those readers do. This is the reason, I think, why I at least am very distressed to find publishers using photographs of real, identifiable people to represent my characters on the covers of novels. It limits the readers' imaginations. And beyond that, of course, it has a blasphemous feeling – as though images are being stolen and made, stolen from the photographed, interposed into my world, graven images that are somehow illicit.

Painted portraits appear as objects in fictions in many ways. A novel may use a portrait as an imagined icon or unifying motif. I began to haunt the National

Portrait Gallery in 1968 when I was planning a novel –
then provisionally entitled *A Fugitive Virtue* – about
the 1950s, the time of the coronation of Elizabeth II,
which was referred to as the New Elizabethan Age.
Antonia Fraser took me to hear Flora Robson perform
a verbal portrait of Elizabeth I in front of the portrait
then known as the Darnley Portrait. At the time I was
teaching literature to art students, in the days of hard-
edged abstraction, when the words 'national' and
'portrait' were both deeply suspect. My planned novel
was already concerned with the differences between
the art and literature of the times of the two queens.
The Darnley Portrait dazzled and then obsessed me. I
used the performance as a prologue to my 1953 novel.
Here is the description – in the words in the novel – of
the painting.

> There she stood, a clear, powerful image, in her airy
> dress of creamy stiff silk, embroidered with golden
> fronds, laced with coral tassels, lightly looped with
> pearls. She stood and stared with the stillness and
> energy of a young girl. The frozen lassitude of the long
> white hands exhibited their fineness: they dangled or
> gripped, it was hard to tell which, a circular feathery
> fan, whose harsh whirls of darker colours suggested a
> passion, a fury of movement suppressed in the figure.

3

> There were other ambiguities in the portrait, the longer
> one stared, doublenesses that went beyond the obvious
> one of woman and ruler. The bright-blanched face was
> young and arrogant. Or it was chalky, bleak, bony, any
> age at all, the black eyes under heavy lids knowing and
> distant.
>
> Her portraits had been treated as icons and as
> witches' dolls: men had died for meddling with them in
> various ways, such as stabbing, burning, piercing with
> hogs' bristles, embedding in poison.

I had been obsessed since childhood with the figure of
the solitary clever woman, who avoided her mother's
fate by using her wits and remaining single, separate, a
virgin. I read *Astraea*, Frances Yates's wonderful study
of the iconography of Elizabeth I, which shows her
knowingly replacing the Catholic Virgin Mary with
the secular Virgin Queen, whose imagery relates her to
dangerous moon goddesses, Diana, Astarte, turret-
crowned Cybele. I connected her to Spenser's Dame
Nature, a perfect androgyne or hermaphrodite, who
'hath both kinds in one'. The whiteness of the face in
the portrait itself called up Keats's phrase 'bright-
blanched', which refers to the sempiternal whiteness of
the face of his undying goddess Moneta – 'deathwards
still progressing/ To no death was that visage. It had

passed/ The lily and the snow' . . . The remembered painted face became an image in itself which the novel began to conjure with. I changed the title to something more iconic and more substantial – *The Virgin in the Garden*. My heroine already had her narrow face and red hair – but that was also rooted in secret family portraiture. Many women in my family have that narrow face, that red hair. Nothing has only one original in a fiction.

Many of the characters in *The Virgin in the Garden*, not only the central one, see themselves in the Darnley Portrait as in a mirror, more or less true, more or less distorting. Novelists have played in different ways with characters who use portraits from other times and places as temporary mirrors to see themselves with a difference. One of the most moving is Henry James's Milly Theale in *The Wings of the Dove*. Milly is shown, by Lord Mark, a striking resemblance between her own face and that of a Bronzino portrait, which appears to be, or to resemble, his portrait of Lucrezia Panciatichi. This resemblance, to readers who know the portrait, gives a clear visual idea of Milly's look. But Milly's thoughts about the portrait are those of a woman who has received a death sentence, who knows she is

mortally ill. She considers the paradoxical timeless-
ness and deadness of portraits.

> . . . she found herself, for the first moment, looking at
> the mysterious portrait through tears. Perhaps it was her
> tears that made it just then so strange and fair – as
> wonderful as he had said: the face of a young woman, all
> splendidly drawn, down to the hands, and splendidly
> dressed; a face almost livid in hue, yet handsome in
> sadness and crowned with a mass of hair, rolled back
> and high, that must, before fading with time, have had a
> family resemblance to her own. The lady in question, at
> all events, with her slightly Michael-angelesque sadness,
> her eyes of other days, her full lips, her long neck, her
> recorded jewels, her brocaded and wasted reds, was a
> very great personage – only unaccompanied by a joy.
> And she was dead, dead, dead.

The portrait here too is a paradox – representing both
life, death, and life-in-death, a kind of false eternity.
Milly's resemblance to it is pointed out to her by an
admirer who partly assimilates her into the world of
art by seeing her resemblance to a great work of the
past. Marcel Proust, in *À la recherche du temps perdu*, is
both touching, analytic and adroitly satirical about the
way in which the aesthete, Swann, gives value to the
woman he is obsessed with by perceiving in her a

resemblance to Botticelli's women. In *Du côté du chez Swann* Odette becomes beautiful in his eyes because he can see her as the daughter of Jethro in the fresco. Proust shows precisely how the two faces become one in Swann's mind.

> He looked at her; a fragment of the fresco appeared in her smile and in her body . . . and although no doubt he only thought of the Florentine masterpiece because he discovered it in her, nevertheless this resemblance gave her in turn a beauty that made her more precious. Swann reproached himself for having underestimated the value of a creature who might have been seen as adorable by the great Sandro.
>
> The words, 'Florentine masterpiece', were beneficial to Swann. They made it possible for him, as a kind of password, to open, for the image of Odette, an entrance into a world of dreams from which she had so far been barred, where she took on a nobility.

Swann goes so far as to place a reproduction of Botticelli's *Daughter of Jethro* on his work table, instead of a photograph of Odette. He admires 'the great eyes, the delicate face which allowed you to guess at the imperfect skin, the marvellous curls of the hair along the drawn cheeks'. Proust does not make it clear whether this description applies to the Florentine

portrait or to the flesh-and-blood woman. He elides them. Swann, he tells us, adapts the idea of beauty he had formed from his aesthetic interests to the idea of a living woman, and transforms this idea into physical characteristics which he can then congratulate himself on having found assembled in a being it is possible for him to possess. Painting-into-woman-into-painting-into-woman, and the final woman as something which can be possessed both sexually and as *objet d'art*.

Much later in the long novel – in *A l'ombre des jeunes filles en fleur* – Proust gives a wry description of Odette's own reaction to being perceived in terms of a Botticelli work of art.

> Odette, who on the contrary sought not to emphasise, but to distract from, or dissimulate, what she disliked in herself – what might, in the eyes of an artist, have appeared to be her character, aspects which, as a woman, she saw as flaws – refused to listen to anything about this painter.

Odette wishes to be conventionally beautiful, even to hide what a painter might have identified as her character. Swann, Proust tells us, possessed a marvellous oriental shawl, blue and rose, which he bought precisely because of its resemblance to the

shawl of the Virgin in the *Magnificat*. Madame Swann refused to wear it. Once only she allowed her husband to commission a *toilette* scattered with daisies, cornflowers, forget-me-nots and bluebells, in the manner of the *Primavera*. Swann still saw in her in the evenings, when she was tired, the attitudes and troubled movements of the Virgin of the *Magnificat*. But he would caution the narrator against any mention of the resemblance – 'she only needs to know about it, to behave differently'. Odette's idea of herself, to which we shall return later, is not constructed by works of art.

Swann idealises the woman he loves by conflating her with the great art of the past. Portraits can represent the past in novels, both directly and indirectly. An unusually subtle historical novelist was Ford Madox Ford, who spent much of his childhood in the studio of his grandfather, Ford Madox Brown. As a young man Ford Madox Ford wrote a life of his grandfather, a study of Rossetti and a book on the Pre-Raphaelites. In 1905 he published an excellent and still surprising book on Holbein. Ford Madox Brown's own historical paintings – Chaucer at the Court of Edward III, or his paintings of Oliver Cromwell talking to Milton and Marvell, or brooding

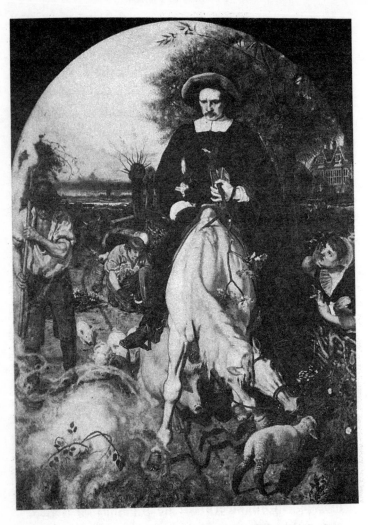

Ford Madox Brown, *Cromwell on his Farm*

10

on a white horse in a busy farmyard scene — required much antiquarian research, and a careful Victorian reworking of faces and attitudes from earlier portraits and tombstones. Ford Madox Ford's historical masterpiece is his trilogy about Henry VIII's marriage to Catherine Howard, *The Fifth Queen*. Graham Greene thought that the brooding, irascible, melancholy figure of the king in these novels was, among other things, a portrait in words of Ford Madox Brown. It has been observed that Ford Madox Ford's fitful and labyrinthine lighting of his interiors, his piling on of accurate visual detail, are in themselves a response to the visual world of the Pre-Raphaelites. But Ford's understanding of the intellectual and cultural history of Europe was intricately involved in his response to the portraits of Hans Holbein and Albrecht Dürer. This understanding in turn, combined with his aesthetic response to the paintings themselves, was the foundation both for the narrative, and for the aesthetic, of his novel.

Dürer, he felt, was part of the old chivalric, Catholic world, whereas Holbein was modern. Dürer's figures came from an outdoor life, went hunting 'in full steel from small castles on rugged and rather Japanese-looking crags'. The flesh of

11

Dürer's figures was 'hardened, dried and tanned by exposure to the air; his whole conception of the external world was more angular . . .' Ford's description of Holbein's lords contains a great deal more than physical notation.

> Holbein's lords no longer ride hunting. They are inmates of palaces, their flesh is rounded, their limbs at rest, their eyes sceptical or contemplative. They are indoor statesmen; they deal in intrigues; they have already learned the meaning of the words 'The Balance of the Powers', and in consequence they wield the sword no longer; they have become sedentary rulers.

Later in his book on Holbein he extends the comparison to the artists themselves and their attitude to their worlds.

> Dürer could not refrain from commenting upon life, Holbein's comments were of little importance.
>
> That essentially was the ultimate difference between the two: it is a serviceable thing to state, since in trying to ascertain the characteristics of a man it is as useful to state what he is not as what he is. Dürer then, had imagination where Holbein had only vision and invention – an invention of a rough-shod and every-day kind. But perhaps for that very reason, the subjects of Holbein's brush – in his portraits – are seen as it

were through a glass more limpid. To put it with exaggerated clearness: we may believe in what Holbein painted, but in looking at Dürer's work we can never be quite assured that he is an unprejudiced transcriber.

Ford's Catherine Howard is a historically improbable fervent Catholic and religious heroine, looking back to the mystery and vision of Dürer's world. But Ford the writer shows a surprising sympathy for the solid realists, Holbein and his new, pragmatic lords. One of his favourite words of praise for any artist – derived from painting – was 'rendering'. He compared Holbein's skill as a 'great Renderer' to the 'marvellous mystery of the instrument, that composure, that want of striving' he found in Bach.

And both move one by what musicians call 'absolute' means. Just as the fourth figure of the *Wohltemperierte Klavier* is profoundly moving – for no earthly reason that one knows – so is the portrait of Holbein's family. The fugue is beautiful in spite of a relatively ugly 'subject', the portrait is beyond praise in spite of positively ugly sitters.

Holbein, he said, was the earliest 'modern' painter. Lely's men and women 'died a century or so later than

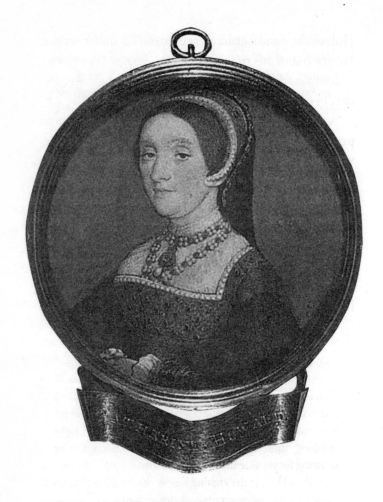

Hans Holbein, *Catherine Howard*

Holbein's – and yet have been dead so much longer. He got out of his time – as he got *into* our time – with a completeness that few painters have achieved – hardly even Velasquez or Rembrandt.'

As a novelist, Ford saw 'rendering' as the central preoccupation – giving 'the air of reality' to his world, what Henry James called 'solidity of specification'. 'It is here that the novelist competes with his brother the painter in *his* attempt to render the look of things, the look that conveys their meanings, to catch the colour, the relief, the expression, the surface, the substance of the human spectacle.' His moral rendering of Henry VIII depends on the portrait images, as well as on the household documents whose publication prompted his researches. Here is his comparison of Holbein's portrait of Henry with the etching by Cornelius Matsys.

> The drawing is an unconcerned rendering of an appallingly gross and miserable man; the etching seems as if, with every touch of his tool, the artist had been stabbing in little exclamation notes of horror. The drawing leaves one thinking that no man could be more ugly than Henry; the etching forces one to think that no artist could imagine any man more obscene.

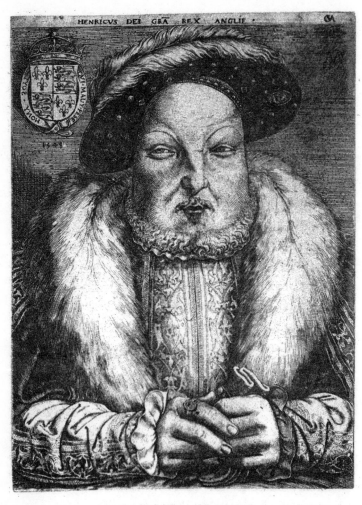

Cornelius Matsys, *Henry VIII*

What is interesting about a close examination of Ford's fictive rendering of this obscene and miserable person is how much it depends on the writer and the reader being haunted by the visual ghosts of these solid portraits. For in *The Fifth Queen* Ford renders his king in a kind of phantasmagoria of almost featureless flesh. Thomas Cromwell sees the king contemptuously as 'the grey failing but vindictive and obstinate mass known as Henry'. Cranmer 'had a vision of the King, a huge red lump beneath the high dais at the head of the Council table, his face suffused with blood, his cheeks quivering'. Ford thought of himself as an Impressionist in language, and these visions, in readers' minds, will all be differently vague, part solid, part emotion. Novels work differently from paintings, and Ford knew how both worked, and occasionally worked together.

There is a sense in which both Ford Madox Brown and Ford Madox Ford are indebted to Robert Browning's great poem about the beginnings of realism in religious painting, *Fra Lippo Lippi*. Browning's painting friar is reproached by his churchly masters for lack of idealism, precisely because his characters are drawn from life.

How, what's here?
Quite from the mark of painting, bless us all!
Faces, arms, legs and bodies like the true
As much as pea and pea! it's devil's-game!
Your business is not to catch men's eyes with show,
With homage to the perishable clay,
But lift them over it, ignore it all,
Make them forget there's such a thing as flesh.
Your business is to paint the souls of men.

Lippo counters with his artistic credo

Or say there's beauty with no soul at all
(I never saw it – put the case the same)
If you get simple beauty and nought else
You get about the best thing God invents:
That's somewhat:

And he appears in his own painting – as he is thought indeed to do.

Up shall come
Out of a corner, where you least expect,
As one by a dark stair into a great light,
Music and talking, who but Lippo! I! –
Mazed motionless and moonstruck – I'm the man!

Virginia Woolf, of course, used past portraits in

18

Orlando, her fictional portrait, devised as a mock biography, of Vita Sackville-West. The Knole portraits of Vita's Sackville ancestors were used to make up Orlando's first few hundred years as a young man. Vita herself was posed by Virginia, as a Lely portrait, for the photographer Lenare. The whole addition to the fictive portrait became a kind of game with mock visual portraits. Hermione Lee writes

> Virginia made Vita pose as a voluptuous Lely for the photographer Lenare ('I was miserable, draped in an inadequate bit of pink satin with all my clothes slipping off, but V was delighted and kept diving under the black cloth of the camera to peep at the effect'.) Vanessa and Duncan then decided to join in, and Vita, even more miserable, and feeling like 'an unfortunate victim', 'was made to sit inside a huge frame while they took endless photographs' . . . Vita was indeed being framed.

This description of Woolf posing Vita the beloved, and giggling over the resulting embarrassment, is one version of the erotic relation between the painter (and writer) and the troubled, reluctant or desired model.

Balzac's *Le chef-d'oeuvre inconnu* is perhaps the most famous piece of fiction about a portrait, except

19

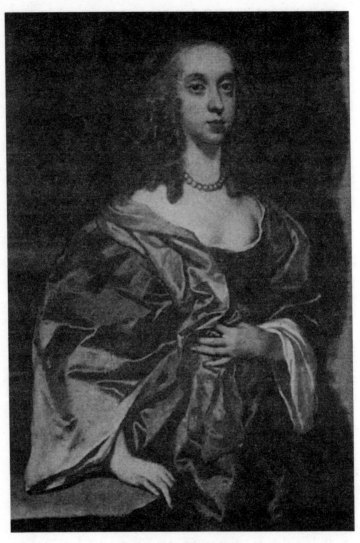

Sir Peter Lely, *Mrs Sackville*

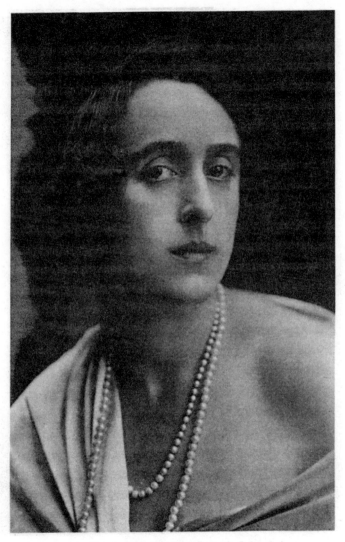

Lenare, *Vita Sackville-West in the style of a Lely painting*

possibly *The Picture of Dorian Gray*, to which we shall come. It is a tale which has attracted the attention of painters, art historians and literary critics, and has been very variously interpreted. Its plot concerns the relations between the real seventeenth-century painters, Nicolas Poussin and Franz Porbus, and Balzac's daemonic creation, the old master, Frenhofer. Frenhofer has spent the last ten years secretly painting a portrait of a woman; he refers to the painting as his mistress and compares himself to Pygmalion, bringing her to life. In order to be allowed to look at this hidden masterpiece, Poussin persuades his own real mistress, Gillette, to pose for the old man. Gillette, who is related to many other wives, mistresses and models in novels, feels that her lover prefers painted women, works of art, to warm flesh, love and embraces. Frenhofer appears to be more jealous of the privacy and solitude of his painted mistress than Poussin is of Gillette's. But when Porbus and Poussin are finally allowed to see the painting, all they can make out is a confused chaos of brush strokes and colours, with one perfectly painted foot still visible in the mist.

There has been much argument as to whether Frenhofer/Balzac was before his time in foreseeing Impressionism and abstract art. Balzac is known to

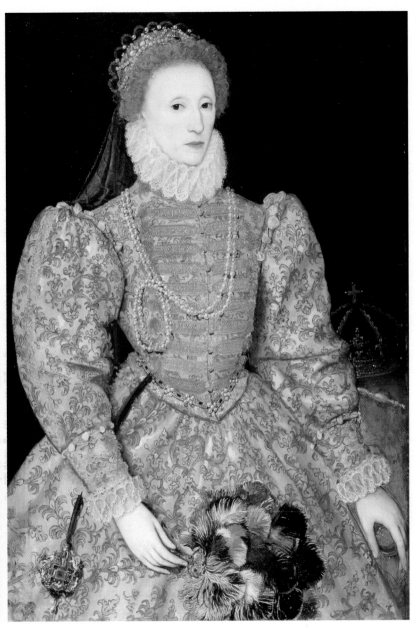

Unknown Artist, *Elizabeth I*

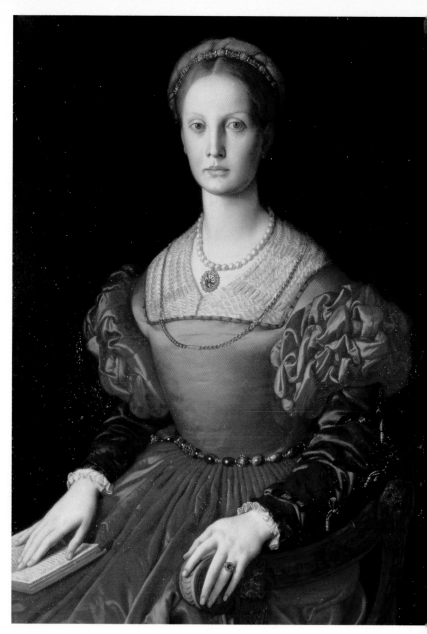

Agnolo Bronzino, *Lucrezia Panciatichi*

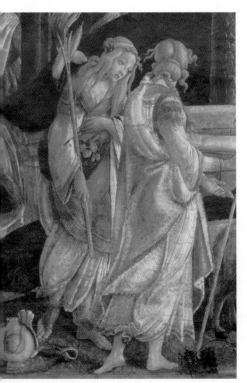

Sandro Botticelli,
The Youth of Moses,
detail with figure of Zipporah

John Ruskin (after Botticelli), *Zipporah*

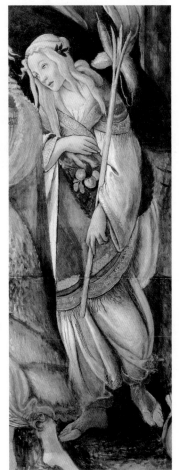

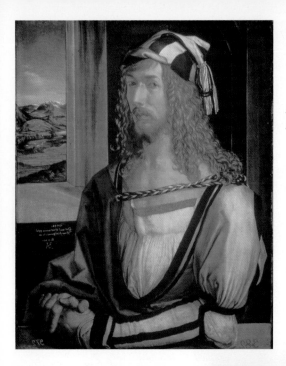

Albrecht Dürer
Self-portrait

Hans Holbein,
The Artist's Wife and Children

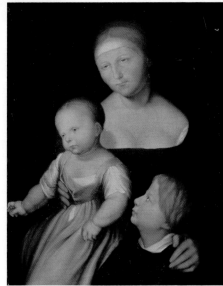

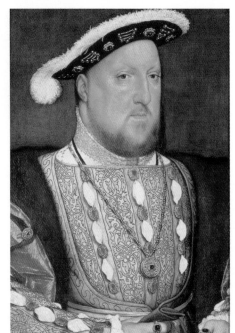

Hans Holbein
Henry VIII

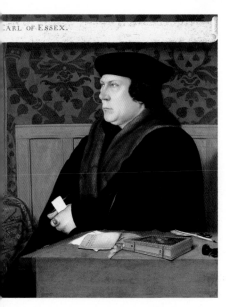

Hans Holbein
Thomas Cromwell, Earl of Essex

Fra Filippo Lippi, *Coronation of the Virgin*
Self portrait, 2nd kneeling figure from left, resting his chin on his hand

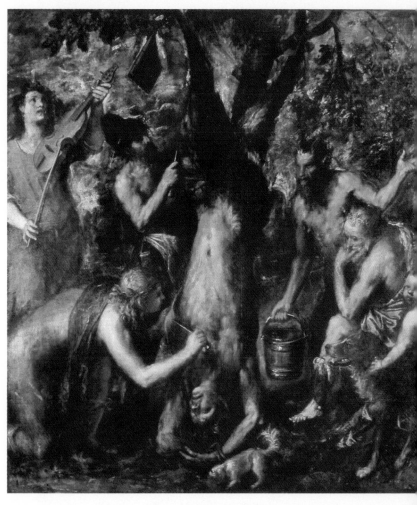

Titian, *The Flaying of Marsyas*

have studied Diderot's writings on paintings and to have revised his text after conversation with Théophile Gautier. Is the portrait a disintegrating disaster, or do the younger painters not know how to look at it? My own view is that a close reading suggests that the painting was a disaster – one step too far in the arduous and sensuously obsessive process of constructing women out of paint. But I would add immediately that Balzac understood, and could represent in words, the relations between brush strokes and light and flesh, the technical problems posed, the difference between the mechanical and the imagined.

Balzac was given to setting his historical scenes with verbal reconstructions of past paintings. He describes Poussin's first sight of Frenhofer in the dramatic light of a stairway. He describes punctiliously and at length the bulging forehead and squashed small nose, the eyes 'sea green, dulled by age' but enlivened by the 'contrast of the pearly white in which the pupils floated', the lashed eyes and the almost invisible eyebrows. He tells his reader, 'You could have said it was a picture by Rembrandt proceeding silently, without a frame, through the darkened atmosphere which is characteristic of this great painter.' Balzac's description details those notes we linger over in a

Rembrandt portrait – and then he turns the whole thing ghostly by making it live, *walking* silently and *without a frame*.

Frenhofer derives from some of E.T.A. Hoffmann's grotesque and sinister persons. His activities with the paintbrush are a sensuous attack on the painted body, and the writer in turn turns his painter's face into a paintbrush animated by desire, 'his beard, trimmed to a point, made sudden threatening movements, stimulated apparently by the itch of erotic imaginings'. His criticism of Porbus's painting of St Mary the Egyptian is precise about where the paintwork does and doesn't bring the painted flesh to life, and his disquisition – which he follows by his own bold retouching of the canvas – makes an interesting riddling image of the portrait as life, death and an unmoving unliving statue.

> No, my friend, there's no blood running under this ivory skin, there's no life welling up in crimson droplets in that network of fine veins beneath the warm shading of the transparency over the temples and the bosom. This part quivers with life, but this one has no movement. Life and death are struggling with each other, all over. Here it's a woman, there it's a statue, and over there it's a corpse.

Life and death, woman, statue, corpse. Portraits in writing shift between these states.

Frenhofer claims to have discovered a technique which renders the work of light on matter without the artificiality of lines and edges. Balzac is concerned with the skin of paint itself, here, with the physical work of the artist. Frenhofer's thick impasto, he says, has hooked light itself and attached it to his surfaces.

> I have managed to catch and fix light itself, and to mix it with the gleaming whiteness of the light tones – and then, using the opposite technique, effacing the roughnesses and the grain of the paintwork, I have been able – through caressing the contours of my figure drowned in the halftones – to eliminate even the idea of drawing, and such artificial methods, and to give the figure both the appearance and the rounded form of nature. Come closer, you'll see the working better. At a distance, it vanishes.

This description moves in a striking way from a description of the material of painting – the captured light, the ridges and textures of the surface, to the rounded material form of the tangible flesh in the depths. The younger men, he tells them, can see the

work of caressing the contour from close up – at a distance, what they see is the form itself, not the work. Frenhofer himself says he idolises Titian, and it seems that Frenhofer's mass of brush strokes resembles the effect Vasari attributes to Titian's late works. The early works, Vasari says, were executed with incredible delicacy and diligence and may be viewed either at a distance or close at hand, whereas the last works 'are executed with bold, sweeping strokes and in patches of colour, with the result that they cannot be viewed from near by, but appear perfect at a distance'. There is something mysterious about this process whereby standing back from a painting reveals clear forms in what from close up appears to be simply a mass of patches of colour and movements of the brush. Porbus and Poussin, examining Frenhofer's painting closely, find a recognisable foot.

Coming closer, they made out, in one corner of the canvas, the tip of a naked foot, which emerged from the chaos of colours, tones, uncertain shadings, a kind of formless fog – but it was a delightful foot, a living foot. They stood motionless with admiration before this fragment which had escaped an unbelievable, slow and progressive destruction. The foot was made visible, like

the torso of some Venus in Parian marble, rising from the rubble of a burned city.

'There's a woman underneath!' cried Porbus, pointing out to Poussin the variegated layers of colour, which the old artist had painted over and over, one on the other, believing himself to be perfecting his work.

The visual image is both strikingly clear – a foot in a tangle, or behind a wall, of brushstrokes – and splendidly vague. Balzac adds to it precise metaphors and comparisons, which make of it a myth of creation and destruction, endlessly succeeding each other – a marble torso of Venus in the wreckage of a burned city, where the marble torso is a dead beauty, even in its survival, and the emerging foot, which suggests the birth of Venus from the formless waves of the ocean. Beauty and form come together out of chaos, and are gathered into it again. Is the old man's reworking an agent of destruction or perfection, or does the former shade imperceptibly into the latter? Language adds the metaphors and the associations, after having called up the mental image. We cannot see the paint to decide whether it is a masterpiece or a failure. The adjective in the title is *inconnu*, unknown, and it is not clear whether the word refers to the historical loss of the work, the

contemporary failure to recognise a masterpiece, or simply the disappearance of the recognisable forms of the subject of the portrait in the dense surface of the paint.

What is also easily brilliant in Balzac's proceeding is the way in which the live foot and the dead torso of the marble Venus shade into the statue which Pygmalion caressed until she became a living woman. Poussin's living mistress has contributed to the final touches of the chaos on the canvas – she has been deconstructed as all matter and light must be in order to be rendered in paint – and Frenhofer believes that he has made a life form. He is the Creator.

> Ah! Ah! he cried. You were not expecting so much perfection. You are in front of a woman, and you are looking for a painting. There is so much depth in this canvas, it is true, the air is so real, that it's hard for you to distinguish it from the air that surrounds us. Where is the art? Lost, vanished! Here you see the very forms of a young girl. Have I not caught the colour, the force, of the line that appears to be the edge of her body? And isn't that the same phenomenon offered to our eyes by objects that inhabit the atmosphere as fish inhabit water? Look at the way in which the contours detach themselves from the background. Don't you feel as though you could run your hand along this

back? It took me seven years to study the meeting
point where daylight joins to objects. Look at this hair,
don't you think it is washed over with daylight? But
she took a breath, I believe. This breast, look at it.
Who would not fall on his knees before her? The flesh
trembles. She will stand, wait . . .

It is interesting that the original title of this tale – still
occasionally used – was the name of the mistress/
model Gillette. When the story was filmed as *La Belle
Noiseuse*, the nature of film made the woman more
central. But *Le chef-d'oeuvre inconnu* is what it says it is
– a tale about the work of rendering, its arcane glories
and its hazards.

Art historians and literary historians are cautious
about what Balzac may or may not have known both
about the past (Titian) and about how far he may
have prophesied the art of the future. They are
cautious about whether he may have spoken to
Delacroix about painting techniques – although it is
possible, and Balzac dedicated a book to Delacroix in
1843. What is not in doubt is the fact that painters in
general respond to *Le chef-d'oeuvre inconnu* with
passion and excitement – as they do not always
respond to writings about painting. Picasso, indeed,
painted *Guernica* in the house in the rue des Grands

Pablo Picasso, *Le Repos du Sculpteur III*, from 'La Suite Vollard'

Augustins in which Balzac's tale begins. In 1927 he began to work on a series of etchings, 'La Suite Vollard', to accompany Balzac's text. These study the relations of painter and model, or models, sculptor and model, with brilliant force and inventiveness, and with varying degress of sensuous realism and chaotic markings. They are always erotic, and always analytic, both of the relationship between artist and sitter, and of the style, the intention, the texture, of the representation.

Probably the most striking reaction to the *Chef-d'oeuvre* was Cézanne's. Emile Bernard, recording his conversations with Cézanne, describes the latter's self-identification with Frenhofer.

> One evening, when I was speaking to him about the *Chef-d'oeuvre inconnu* and about Frenhofer, he rose from the table, stood upright in front of me, and, striking his chest with his forefinger, pointed himself out, without a word, but with this repeated gesture, as being the fictional character himself.

Bernard, writing later about Cézanne, used a phrase from Balzac which, as he remarks, identifies the painter with Balzac's hero: 'Frenhofer est un homme passionné pour notre art qui voit plus haut et plus loin

que les autres peintres.' (Frenhofer is a man, passionate about our art, who sees higher and further than other painters.) There are records of Cézanne talking as though Frenhofer were a real person, and in one of those popular questionnaires of the time, when asked which character in fiction or drama he found most sympathetic, he answered 'Frenhoffer' [sic]. Some of Cézanne's female nudes might be seen to relate directly to *la belle noiseuse*.

Cézanne's self-identification with Balzac's fictive portrait-painter is beautifully – and tragically – complicated by his relations with Emile Zola. Zola was a close childhood friend – the painter and novelist grew up and studied together in Aix-en-Provence, and remained friends for a large part of their lives, although Zola went to Paris and succeeded, first as a journalist, and later as the author of the overwhelmingly ambitious Rougon–Macquart series of novels, whilst Cézanne became more and more reclusive in the south. In 1886 Zola published *L'Oeuvre*, now the fourteenth novel in the series. This title is impossible to translate without loss. In French it means equally 'Work', and 'The Work of Art'. It is translated as 'The Masterpiece' – which indicates its close relationship to Balzac's earlier

work. The novel tells the story of the young painter, Claude Lantier – a febrile genius, the son of Gervaise of *L'Assommoir*, obsessively dedicated to the creation of a great work, and also to work itself. He has a journalist/novelist friend, Sandoz, and marries a young woman, Christine, who takes him in in a storm, bears his son, marries him and models for him. The relations between painter and model-wife take the rivalry between work and woman fantastically further than Balzac did. When Claude first meets Christine he 'steals' an image of her sleeping face and breast for a painting he is making of a naked woman in the open air. Later she consents to pose nude for this painting, which is exhibited in the Salon des Refusés and arouses gales of laughter. Later still, when they are living penuriously in a warehouse she poses for his hugely ambitious painting of Paris and the Ile de la Cité as a huge Woman, a bather rising like Venus from the Seine. Zola's narrative is lengthy and deepens remorselessly. The real woman is the victim of the fanaticism of art. Even in their early days of rural happiness, when Claude paints Monet-like image of women in orchards, in the pink light of a parasol, in red amongst foliage, Zola says, 'He was haunted by the need to paint a figure clad in sunlight,

and from that moment on, his woman became his victim . . .' The woman clothed in the sun is a vision of the apocalypse, but Christine is only human and cannot compete with the imagination.

> Ah, to desire them all, to create them according to his dream, the satin bosoms, the amber-coloured haunches, the soft bellies of virgins, and then to love them only for the beauty of their colours, to feel them rush away, and be powerless to grasp them! Christine was the reality, the object the hand could reach and touch, and Claude was sick of her in one season – Claude the knight of the uncreated, as Sandoz, from time to time, called him, laughingly.

The image of the apocalyptic woman clothed in the sun plays in and out of the natural sunlight of the *plein air* painting of the Impressionists, about whose early works Zola wrote. She is conflated with the image of Pygmalion's statue, moving and living. Zola's greatness lies partly in pushing everything to grotesque extremes, even whilst he keeps a tight hold on the thematic architecture of his narrative. There is an extraordinary moment, comic and terrible, when Claude goes to collect his friend, the sculptor Mahoudeau, who is to be best man at his

wedding to Christine. Mahoudeau lights the stove, and this has an effect on his clay model of a Woman Bathing.

At that moment, Claude, his eyes on her belly, thought he was having a hallucination. The *Woman Bathing* was moving, there was a tremor in the belly, a light ripple, the left leg had stretched out, as though the right leg was about to take a step.

'And those little planes which run down the buttocks,' Mahoudeau went on, noticing nothing. 'I've worked so hard on those. The skin's like satin.'

Little by little the whole statue came to life. The hips rolled, the breast swelled out in a great sigh between the loosening arms. And, on a sudden, the head inclined, the thighs bowed, she fell in a live collapse, with the frantic energy, the agonised leap, of a woman throwing herself to her death.

Claude finally understood when Mahoudeau uttered a terrible cry.

'Christ, it's giving way, she's breaking up.'

The clay, once thawed, had burst the flimsy wood of the frame. There was a cracking; they could hear bones breaking. And Mahoudeau, with the same loving gesture with which he excited himself as he caressed her from afar, held out his arms, at the risk of being killed underneath her. For a second she quivered, then crashed down in one movement, on her

35

face, cut off at the ankles, leaving her feet fixed to the wooden plank.

Claude had rushed out to hold him back.

'Bloody hell. You'll get crushed.'

But, trembling to see her come to her end on the ground, Mahoudeau kept his place with outstretched arms. And she seemed to fall on his neck, he received her into his embrace, tightened his arms around this great, virgin nakedness which moved as with the first stirrings of the woken flesh. He went into her, her amorous bosom flattened against his shoulder, the thighs pushed against his own, whilst the head, fallen off, rolled away on the ground. The blow was so powerful that he was carried away, hurtled against the wall; without letting go of the broken torso, he lay, stunned, at her side.

It is interesting that in translating this into English I have had to choose between 'she' and 'it' to describe the sculpted woman, whereas the French does not require the reader to make this distinction. In French the mind flickers between seeing her as the female and as the 'it' of the art object she was, and the clay to which she is returning. The passage might be said to combine the female image as created life, as erotic object, and as lifelessness and death in one movement of dissolving clay. It is funny and terrible.

Mahoudeau and Claude go to Claude's wedding streaked with the muddy marks from the melted woman, as though they were grave-diggers coming from a funeral.

By the end of the novel Claude and Christine are living in the studio, with almost nothing but the huge painting of the symbolic Woman, who is Paris herself, in all her beauty and corruption. Posing for this work drains the life, and also the health and beauty from Christine. She feels she is being sacrificed to her monstrous rival.

For some months, the pose was a torture to her. Their good life as a couple had ended. A *ménage à trois* had come into being, as though he had brought a mistress into the house, this woman, whom he was painting in her own image. The huge painting stood high between them, separated them with an unsurmountable wall. He lived on the other side of that wall, with that other. She was being driven mad, jealous of her copied double, aware of the wretchedness of this kind of suffering, not daring to admit her pain, about which he would only have made jokes. She was nevertheless not mistaken. She felt clearly that he preferred his copy to herself, that the copy was the object of his adoration, the single object of his attention and his affections at all times. He was killing her with posing

37

to make the other more lovely, his joys and sorrows came only from the other, according to whether she seemed to him to live, or to languish, beneath his brush.

And Christine, in her mind, unmakes this immobile and terrible invader into the elements of which she is composed (as Mahoudeau's clay woman returned to the original mud). She is 'A dust, a nothing, some colour on some canvas'. She has ruined their paradise and their happiness – and killed their sick and neglected son.

When Sandoz, the good friend who analyses Claude's dangerous absolute obsession, sees the painting he finds the central figure too large, hallucinatory, out of keeping with the realism of the rest of the painting of the river and the isle. He sees the painting as a failure of power, caused by too great a desire, and an insufficient execution. The Woman is lurid and alarming – but, as Frenhofer's opaque 'little wall' of brush strokes can now be felt to have prefigured the marks of the Impressionists, Claude Lantier's Woman prefigures the sphinxes and dark goddesses of symbolism, Gustave Moreau and Odilon Redon. Christine finally fights a battle with her deadly

rival and briefly induces Claude to see his creation as inanimate, a hollow metallic construction, an idol without life.

'All right, look at her, your woman up there. Look what a monster you have made of her, you madman. Is there anyone with a body like that? Do people have thighs made of gold and flowers under their bellies? Wake up, open your eyes, come back into existence . . .'

Claude, obeying the masterful gesture with which she pointed at the painting, had stood up and looked. The nightlight, balanced on the top of the ladder, lit up the Woman like an altar candle, whilst the rest of the huge room remained in the shadows. He was finally wakening from his dream, and the Woman, seen thus, from below, with a few backward steps, stupefied him. Who could have painted this idol of an unknown religion? Who had made her of metals, of marbles, and gemstones, flourishing the mystic rose of her sex between the precious columns of her thighs, beneath the sacred vault of her belly? Was it himself, who, unknowing, was the craftsman of this symbol of insatiable desire, of this extra-human image of the flesh, turned to gold and diamond in his fingers, in a vain attempt to make it into life?

Christine persuades him to abandon the painting. They make love, and she believes she has triumphed.

But the next morning she finds Claude has hanged himself, his face turned towards the Woman.

L'Oeuvre is interesting because it contains both portraits in paint and clay, and portraits in words. It is very much a *roman à clé*. The novel deals with the early struggles of the Impressionists and Claude Lantier has elements of Manet, Monet and Zola's old friend, Cézanne. Monet – to whom Zola sent a copy – wrote to Zola complaining that the portrait of their group would do them harm. He acknowledged that Zola had taken care that his characters were not based on any single person, living or dead.

> Your books always give me great pleasure and this one interested me all the more because it raises issues of art over which we've long been battling. I've just finished it and I confess it has left me troubled, worried. Though you make certain that none of your characters should resemble any one of us, I am still afraid that our enemies in the press and in the public at large may seize this pretext to call Manet and the rest of us failures – which, I must believe, was not your intention.

Monet's anxiety – shared in different degrees by other painters – was the common one of those who find themselves 'in' people's novels, and know that they

will be haunted thereafter by an almost certainly unwanted doppelgänger, a public image or simulacrum whose sayings, feelings, and even life history, will be confounded with their own. Portraits in novels feel to the portrayed most often like attacks – and experienced readers know that the careful work of distinguishing original from copy can be undone by the public desire for image, myth, personality, story. A sitter may feel threatened by a painting but in a quite different way: vanities or weaknesses may be exposed, or the painting – we shall come to this – may end up as a portrait of the artist rather than of the sitter. It inevitably must, to some extent. We shall come also to Manet's portrait of Zola, which is a wise masterpiece. Monet was right to think that the existence of Claude Lantier impinged on his own work and existence. His most urgent anxiety was for his work and the public perception of his work.

Cézanne, Zola's childhood friend, reacted more personally and with violence. Zola sent him a copy of the novel, and he wrote back on 4 April 1886, with deliberate formality.

My dear Emile

I have just received *L'Oeuvre*, which you arranged to send me. I thank the author of *Les Rougon-Macquart* for this kind token of remembrance, and request that he

allow me to clasp his hand as I think about bygone years.
All yours, writing under the impetus of another time,
Paul Cézanne.

This was the last communication of any kind between
them. It is clear that the painter felt both insulted and
wounded by the portrait of Claude Lantier in the
book. Emile Bernard, in his *Souvenirs de Paul Cézanne*,
published in 1907, records Cézanne's forthright and
angry opinions.

> He had a very mediocre intellect, and was a detestable
> friend; he saw nothing except himself; which is why
> *L'Oeuvre*, in which he claimed to have portrayed me, is
> simply a dreadful distortion, a lie told for his own self-
> glorification.

In the same recorded conversation Cézanne reminisced
about the days in which, on his rare visits to Paris,
Zola, a rising journalistic star, had presented him to
Manet.

> I was very taken by this painter and his kind welcome,
> but my natural shyness prevented me from going to see
> him often. Zola himself, as he established his own
> reputation, was becoming ferocious and seemed to
> receive me only to be obliging; so much so, that I found

it unpleasant to see him; and I went on for many years without seeking him out. One fine day I received *L'Oeuvre*. That was a blow to me; I recognised his intimate thoughts about us. To be precise, that book is a very bad book, and completely false.

Zola had dedicated an earlier novel about Claude Lantier to Cézanne. He does not appear to have recognised or understood his friend's genius, which is perhaps not surprising – it has been pointed out that the probability of two great artists finding themselves in the same class in the same provincial city was not great. But it has also been pointed out – by Frederick Brown, Zola's biographer, and others – that Claude Lantier, the ambitious, febrile failure, was very much a self-portrait of the writer, involved in the portrait of the painter. Zola's sympathetic, and easily recognisable, self-portrait in *L'Oeuvre*, is Sandoz the writer, an obsessive worker, aware that his life is being drained into, and sacrificed to, his work (*l'oeuvre*), which torments him, is never satisfactory or finished, but a burden from which publication briefly releases him. Sandoz shares Zola's belief in a new literature about physiological man, an evolved creature, whose body and mind are one

inseparable animal thing, constructed by heredity and the pressures of society. Sandoz is a 'naturalist' who records human life as part of nature. Zola praised Manet for being a naturalist and wished to believe that they were working in the same mode. His early praise for Manet's Olympia is distinguished by his ability both to describe Manet's style, and his perception that this nude was not a classical ideal but 'this girl of our own time whom you meet every day on the pavements, hunching her thin shoulders under a flimsy and faded shawl'. Manet, he said, 'proceeds in the way nature itself proceeds, in clear masses, in large patches of light, and his work has the slightly rough, austere look of nature. Moreover, there are deliberate statements; art only lives through fanaticism. And these statements [*partis pris*] are that dry elegance, that violence of transitions, I have pointed out.' The precision, the elegant dryness, the sure handling of mass and light he admires in Manet are what Claude Lantier loses in his vast and monstrous Woman. Sandoz is able to contemplate – with pity and terror – the process by which Claude 'loses his footing, and is sucked down into the heroic madness of art'.

At first he had been simply astonished because he had had more faith in his friend than in himself, he had thought of himself as secondary, since their schooldays, thinking of his friend as a master, one of those who make the revolutions of their time. And then, a painful tenderness came over him at the sight of this bankruptcy of genius, a bitter and bleeding pity, before this dreadful torture of impotence. Does one ever know, in art, who is a madman? All failures touched him to tears, and the more the painting or the book went astray, turned into a grotesque and lamentable misuse of energy, the more Sandoz shivered with an urgent need, out of a kind of charity, to lay them reverently to rest, these battered and stricken casualties of their work.

This presents the writer as composed and compassionate, and it is easy to see how the reading of paragraphs like this might strike Zola's own old schoolfriend as insufferably condescending. But Zola's own art does not have the dry elegance he precisely ascribes to Manet. It is always on the edge of running into the grotesque, the over-insistent, the dangerous areas into which Claude ventured and sank. Portrait and self-portrait overlap in many places in this novel, character is fluid and shifting.

In 1868 Zola was challenged by a friend to include Manet's portrait of himself in his account of the Salon.

It is one of the most interesting records of the thoughts of a man who works with words, watching himself appear on the canvas of a man who worked with colour and light. The thoughts he records look forward to *L'Oeuvre* twenty years later.

> I remember the long hours of posing. My limbs grew numb, my eyes grew tired with staring into bright light, and the same thoughts floated perpetually in my head, with a soft, interior sound. The stupidities out in the streets, lies and platitudes, all this human noise that runs away uselessly like dirty water, were far away, very far away. It seemed to me that I was outside the earth, in an air of truth and justice, full of a disdainful pity for the poor creatures who floundered about below.

Zola writes his own portrait of the artist as portrait-maker.

> From time to time, out of the half-sleep of the pose, I watched the artist, standing in front of his canvas, his face tense, his eye clear, intent on his work. He had forgotten me, he no longer knew I was there, he was making a copy of me, as he would have made a copy of any other human animal, with an attention, an artistic awareness, that I've never seen anywhere else.

Zola's thoughts range over Manet the misunderstood genius, and the mockery of the ignorant public, as he watches the canvas fill with his own image. He suggested, he says, that Manet might invent a detail here or there, without copying, and is told that the painter can do nothing that is not an exact analysis of the natural object in front of him. This pleased Zola, who was able to define Manet in his own image, a scientific artist, a naturalist. He ends with a detached critical description of the technical merits of his own portrait as painting.

> I defy any other portrait-painter to put a figure into an interior, with the same energy, without the still-lifes surrounding the head impinging on its image.
>
> This portrait is a gathering of difficulties which have been overcome – from the pictures in the background, and the charming Japanese screen on the left, to the finest details of the face, everything is held in a wise, clear and brilliant tension, so real that the eye forgets the assemblage of the objects, and sees only a harmonious whole.

The most innocent victim of Claude Lantier's obsessive work is his sickly child, Jacques, ignored by both his parents, slowly weakening, and dying almost

unnoticed. Portraits, as I have been suggesting, are a rendering of death as much as a prolongation of a moment of life, and Claude is tempted to copy the just-dead face.

> And when he went past the little corpse, he couldn't prevent himself from glancing at it. The eyes, wide open, unmoving, seemed to have a power over him. At first he resisted, then the confused idea took precise form and ended by becoming obsessive. In the end he gave in, took a small canvas, and began on a study of the dead child. For the first few moments his tears stopped him seeing, drowning everything in a mist: he continued to wipe them, and carried on with a trembling brush. Then the work dried the eyelids, the hand steadied; and soon what was there was no longer his frozen son, but only a model, a subject whose strange nature was exciting. The exaggerated delineation of the head, the waxy tone of the flesh, the eyes like holes opening into emptiness, all excited him, warmed him like fire. He stepped back, felt pleased with himself, smiled vaguely at his work.

A very moving painting analogous to this one is Monet's portrait of his wife, Camille, on her death-bed. This extraordinary work clearly shows the dying woman's face, with its taut mouth and heavy eyelids.

But it then dissolves into rushing sweeps of pinks and mauves, a whirling mist of colour. Monet is said to have been fascinated by 'the coloured gradations which death was imposing on her motionless face'. Monet is said to have rushed from the room in distress at the way he was turning life, or death, into art at such a moment. She appears to be dissolving into form-lessness, into coloured matter. She is a version of the traditional death-mask, the image of the final human presence after death and before dissolution. She is also akin to Frenhofer's perfect woman, drowned in a sea of incoherent marks. This real portrait, like Balzac's imaginary one, could be said to be an image, exactly, of decomposition.

Writers are not always interested in the wordless skin of paint and rhythms of marks that make up the painted portrait. One who was was Proust, who described Monet's painting of Vétheuil in the mist as a process of 'painting [the fact that] one does not see what one sees'. His analysis of his narrator's process of understanding the way in which the imaginary painter, Elstir, had painted his wife is of great interest. The Narrator finds Madame Elstir heavy and ugly. Elstir calls her 'ma belle Gabrielle'. The painter has turned his wife into his own mythology, his own religion – he

reconstructs her form in 'certain arabesques', 'a certain canon' of marks which turn her into a kind of divinity 'because he has devoted all his time, all the effort of thought of which he was capable, in a word, all his life, to the task of distinguishing these lines more precisely, of rendering them more faithfully'. The narrator's visual education leads him to recognise a new kind of beauty in Madame Elstir, through the portraits. He remarks

> it may be that there are certain bodies, certain occupations, certain privileged rhythms, which so naturally conform to our ideal, that even without genius, simply by copying the movement of a shoulder, the tension in a neck, we may make a chef-d'oeuvre; that is the age at which we love to caress Beauty with our gaze, outside ourselves, near ourselves, in a tapestry, in a fine sketch by Titian discovered in a second-hand shop, in a mistress as lovely as the Titian sketch. When I had understood that, I was no longer able to see Madame Elstir without pleasure, her body lost its heaviness, for I filled it with an idea, the idea that she was an immaterial creature, a portrait of Elstir.

This elegant meditation introduces the ambiguity, tauter in the French, that the paintings of a woman as

an idea, the idea of beauty, are also a self-portrait ('Un portrait d'Elstir' – a portrait by Elstir, a portrait of Elstir – the French does not distinguish). The idea of portrait as self-portrait can exist in psychological terms, even violently psychological terms, as we shall see. But Proust is interested in the paint, and in the formal properties. Madame Elstir is where Elstir's idea of beauty is discovered and is therefore the image of his essential self.

Perhaps the most famous portrait in Proust's novel is the portrait by a young Elstir of 'Miss Sacripant', which turns out to be an early portrait of Odette in *travesti*. It is remarkable, first of all, as a virtuoso rendering of a non-existent painting in very exact words, so that the image can be very precisely imagined (though, as I suggested at the beginning of this essay, no two readers will imagine the same image, all the same). Proust begins his description of the watercolour with a disposition of the body, the clothing, the pose.

It was – this watercolour – the portrait of a young woman, not pretty, but of an odd type, wearing a small hat, not unlike a bowler, bordered with a cerise ribbon; one of her gloved hands held a lighted cigarette, whilst the other held up, at knee-height, a kind of wide garden hat,

51

a simple screen of straw against the sun. At her side, a flower-holder full of roses on a table.

He then sets the time, or doubts about the time, and place, or uncertainty about the place, with an on-looker's reflections on how these doubts change perception of the painting.

> Often, as in this instance, the singularity of these works derives from the fact that they were executed in particular circumstances, of which we are not, at first, clearly aware – for example whether the strange costume of a female model is a fancy dress, or whether on the other hand the red robe of an old man who looks as though he put it on for the sake of a fantasy of the painter, is his professorial gown, or a councillor's dress, or the scarlet of a cardinal. The ambiguous character of the being whose portrait was before my eyes derived, without my knowing it, from the fact that it was a young actress of earlier days in *demi-travesti*. But her bowler, under which her hair was *bouffant* but short, her velvet jacket, without reveres, opening on a white shirt-front, caused me to hesitate about both the style and the sex of the model.

Proust then transfers his attention to the artistry, the craft-work of the imagined painting, remarking that

nothing was simply recorded for its *utilité*, its immediate usefulness. He describes textures:

> the clothing of the woman surrounded her with a substance which had an independent charm, a related charm [*fraternel*], and, if the works of industry were able to compete with the marvels of nature, a charm as delicate, as delicious to the touch of the glancing eye, as freshly lit as the coat of a cat, the petals of a carnation, the feathers of a dove. The whiteness of the shirt-front, with the fineness of fine snow, whose light and airy folds had tiny bells like those of lily of the valley, was starry with the bright reflections of the room, themselves sharply edged and finely shaded, as though bouquets of flowers were embroidered on the cloth. And the velvet of the jacket, brilliant and pearly, had here and there a ruffled touch, a frayed edge, a furred look, which was reminiscent of the dishevelled shape of the carnations in the vase.

He then moves back to the sexual and moral ambiguity of the painting (and the sitter) and claims that this ambiguity was in itself an aesthetic quality to Elstir, comparable to the furriness of the flowers, or the way the light made shapes, a metaphoric doubleness, though he doesn't quite say this. Proust describes the hermaphrodite look of the *travesti*.

Within the lines of the face, the sex appeared to be about to be defined as a young woman, slightly mannish, then dissipated and further on was more suggestive of the idea of an effeminate youth, corrupt and dreamy, and then the image escaped again, evaded capture. The dreamy sadness of the gaze, in the very contrast with the accessories drawn from the world of weddings and theatre, was not the least disturbing thing about it. Moreover, it led one to think that it was fabricated, and that the young creature who appeared to be offered up to caresses in this provocative costume, had most probably found it intriguing to incorporate a romantic hint of secret emotions, an undivulged grief. At the bottom of the portrait was written Miss Sacripant, October 1872.

Proust claimed that all artists in their early works, discover the laws – indeed the formula – of expression of their unconscious gift. They use these rules and formulas to explore, to render, the outside world, and its subjects, in their *chefs-d'oeuvre*. The next stage is the development of a kind of superstitious respect both for the subjects and for the methods and mannerisms of their early work. Proust considers Elstir in these terms, and remarks that just as Swann the connoisseur had become arrested in the contemplation of the 'beauty of life', a meaningless phrase, conceived from a point of

view quite separate from the making of works of art, so Elstir, as his creative energy flagged, fell into an easy repetition of his old forms and manner out of laziness mixed with a kind of fetishism of his own past energy and vision. The painted Odette of Miss Sacripant is not recognisable as Odette. But she has an identity. Her face, her body, her look, are not Odette, but they are very familiar to the onlooker.

> They recall, not the real woman, who never comported herself in this way, whose habitual carriage never took on this strange and provocative arabesque, but other women, all the women painted by Elstir, all of whom he liked to arrange in this way, looking out, the arched foot protruding from the skirts, the large round hat, corresponding symmetrically, at the level of the knee which it conceals, to that other flat disk, the face.

And the faces of the women who were Elstir's subjects have dated, not only because the styles of their youth have gone out of fashion, but because the look h e gave them has also dated, as the women painted by Monet or Whistler have dated and become part either of history or of oblivion. Elstir's Miss Sacripant is a travesty of Odette in two senses. He has replaced her genetic family face with the family face of his own models.

*

The Picture of Dorian Gray is a sustained – and drama-tised – meditation on the life and death of portraits. Like Elstir contemplating his wife in his youth, Basil Hallward sees the beautiful Dorian Gray as an embodiment of his own idea of beauty, like the classical Antinous. '"A dream of form in days of thought"; who is it who says that? I forget; but it is what Dorian Gray has been to me.' He also makes it quite explicit that the dangerous portrait is a portrait of the artist. He will not exhibit it for that reason.

> ... every portrait that is painted with feeling is a portrait of the artist, not the sitter. The sitter is merely the accident, the occasion. It is not he who is revealed by the painter: it is rather the painter who, on the coloured canvas, reveals himself. The reason that I will not exhibit this picture is that I am afraid I have shown in it the secret of my own soul.

Part of Basil Hallward's secret soul is the erotic arousal created by Dorian Gray. Dorian himself sees the image much more in terms of his own life and death. Before it begins its terrible change and human ageing, he says, 'There is something fatal about a portrait. It has a life of its own.' This remark is made as a reason for refusing to sit again – Basil says, 'You spoil my life

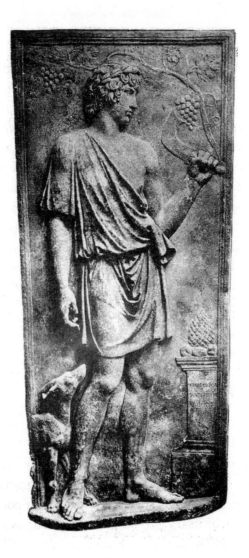

Antinous

as an artist by refusing, Dorian. No man comes across two ideal things. Few come across one.' Dorian, the perfect narcissist, laments that the picture will never age. 'I shall grow old and horrible and dreadful. But this picture will remain always young. It will never be older than this particular day of June . . .' And 'I am jealous of everything whose beauty does not die. I am jealous of the portrait you have painted of me.'

The novel is elegant, decadent, and also toughly constructed. As the beautiful man is unnaturally arrested at the high point of his summer loveliness, so the paintings in the tale take on the unnatural functions of passing time and decaying flesh. Dorian wanders through a portrait gallery full of his corrupt and evil ancestors, seeing in them a genealogical, or genetic, pattern of corruption and evil.

> To him man was a being with myriad lives and myriad sensations, a complex multiform creature that bore within itself strange legacies of thought and passion, and whose very flesh was tainted with the monstrous maladies of the dead. He loved to stroll through the gaunt cold picture-gallery of his country house and look at the various portraits of those whose blood flowed in his veins.

This perpetually youthful Dorian amongst the dead is related to Woolf's Orlando, constantly renewed amongst the Sackville-West ancestors. He is as unfading as the young man preserved in Shakespeare's sonnets. He sees the uncanny portrait as a mirror with a difference, and mirrors reappear in many other contexts in the novel.

> For there would be a real pleasure in watching it. He would be able to follow his mind into its secret places. The portrait would be to him the most magical of mirrors. As it had revealed to him his own body, so it would reveal to him his own soul. And when winter came upon it, he would still be standing where spring trembles on the verge of summer. When the blood crept from its face and left behind a pallid mask of chalk with leaden eyes, he would keep the glamour of boyhood. Not one blossom of his loveliness would ever fade . . . Like the gods of the Greeks he would be strong, and fleet, and joyous. What did it matter what happened to the coloured image on the canvas? He would be safe. That was everything.

The strange, riddling, uncanny effect comes from stopping to try to imagine the blood creeping from the face of 'the coloured image on the canvas'. What blood, how constituted? How in a painted face can

blood drain away to leave a 'pallid mask'? What is the relation between a mask and a portrait when they are the same image? Dorian compares the picture to some lines in *Hamlet*, 'Like the painting of a sorrow/ A face without a heart'. These sentiments about the unreality of feeling lead on to reflections about actors, who have a riddling resemblance to portraits, being the images of mere semblances of passion, life and death. Dorian falls in love with Sibyl Vane because he falls in love with her performances as Viola and Juliet, with her art. When she falls in love with him, she becomes real, and suddenly sees the theatre as flimsy and unreal. The words of her exultant speech to Dorian connect to the metaphors and ideas of the whole novel.

> Tonight for the first time I became conscious that the Romeo was hideous, and old, and painted, that the scenery was vulgar, and that the words I had to speak were unreal, were not my words, were not what I wanted to say. You had brought me something higher, something of which all art is but a reflection. You had made me understand what love really is. My love! My love! Prince Charming! Prince of life! I have grown sick of shadows.

The language here is full of complex meaning. *Dorian Gray* is full of Shakespearean references – the line about 'a painting of a sorrow' is Claudius, who has murdered Hamlet's father, urging Laertes to feel *real* grief for his own murdered father, and to murder Hamlet. *Hamlet* turns on simulations of murder and passion – the play in a play re-enacts the murder, and the players are exhorted to 'hold, as 'twere, the mirror up to nature'. Wilde himself preferred art to life, said the most tragic thing he knew was the death of Lucien de Rubempré, and used the mirror and nature image in his lapidary Preface to *Dorian Gray*.

> The nineteenth century dislike of Realism is the rage of Caliban seeing his own face in a glass.
> The nineteenth century dislike of Romanticism is the rage of Caliban not seeing his own face in a glass.

He would have concurred with Dorian that life should be turned into art to be looked upon – 'to become the spectator of one's own life, as Harry says, is to escape the suffering of life'. Poor Sibyl Vane, becoming real, feeling love in a flesh and blood heart, becomes ugly, vulgar and undesirable in Dorian's eyes and, fatally, loses the ability to act a part. She uses the image of *paint* to describe the efforts of the ageing actor to mask

the decay of his flesh, and this contrasts with Dorian, whose fleshly imperfection has been transferred to paint. She then goes on to claim that all art is '*a reflection*' and ends with a direct quotation from Tennyson's Lady of Shalott, who was condemned to live in a tower with a loom and a mirror, to weave a tapestry and to see the real world only as it was reflected in the mirror. 'I am half-sick of shadows', cried the Lady, who was a symbol of Romantic Art, and Sibyl echoes her – 'I have grown sick of shadows.' She disgusts Dorian in her reality and kills herself. Lord Henry, the aesthete and evil genius of the piece, tells Dorian not to mourn and to turn her death back into art. 'You must think of that lonely death in the tawdry dressing-room simply as a strange lurid fragment from some Jacobean tragedy, as a wonderful scene from Webster, or Ford, or Cyril Tourneur.' He dismisses Sibyl into unreality. 'The girl never really lived and so she has never really died.' Like a work of art, a painting, a mask.

Dorian kills Basil, the painter, on an impulse, when he has shown him the full horror of the degenerate portrait. He kills him with the knife with which he will later stab the figure in the portrait – after which he himself is found dead, 'withered, wrinkled and

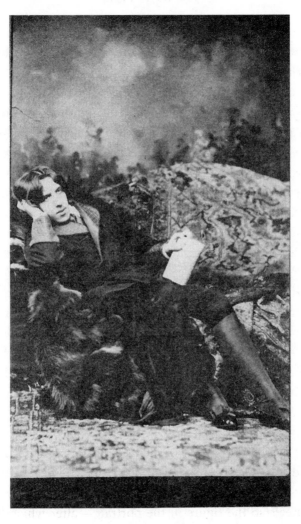

Napoleon Sarong, *Oscar Wilde*

loathsome' with the knife in his own heart, under the portrait, which has resumed his youthful loveliness. On his way to murder the portrait, he stops and looks at himself in a 'curious mirror that Lord Henry had given to him, so many years ago now', with white-limbed Cupids laughing round it. He thinks of people whose lives his beauty has destroyed. 'Then he loathed his own beauty, and flinging the mirror on the floor crushed it into silver splinters beneath his heel.'

The Picture of Dorian Gray is of course also a Portrait of the Artist, who was Oscar Wilde. All three main characters have large elements of Wilde in them, Dorian's aesthetic detachment, Lord Henry's cynicism, Basil Hallward's gentle love for the younger man. Hallward was also said to be based on Charles Ricketts, who painted the portrait of his lover Charles Haslewood Shannon, and was painted by Shannon in return – a remarkable double portrait. The human images are amalgamated and diffused, as painter and writer in *L'Oeuvre* make up a patchwork image of Zola.

The Picture of Dorian Gray is full of imaginary colours and solid objects. It is always odd, and odder on reflection, to see film versions of novels that were

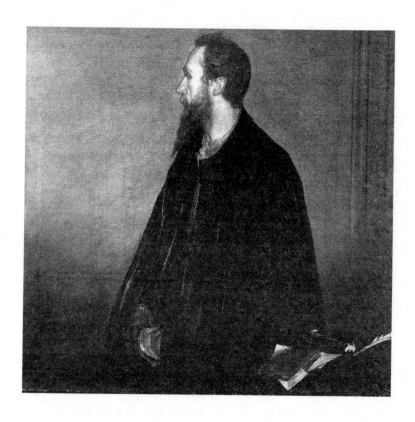

Charles Ricketts, *Charles Haslewood Shannon*

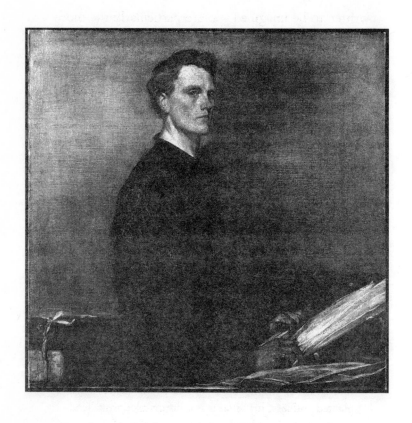

Charles Haslewood Shannon, *Charles Ricketts*

written to be imagined – more particularly the more visually evocative the naked words manage to be. Acting separates out into individual bodies those overlapping and mirrored metaphors and feelings that are the tissue of a text. Films also make visible what was invisible – in this case, most particularly the demonic and changing portrait.

An interesting example of an analogous effect can be found in one of Henry James's greatest ghost stories, *The Jolly Corner*, in which a Europeanised American, returning to his family home after many years away, finds the dreadful ghost of what he would have become if he had stayed. James was an art critic, among other things, and wrote essays on the National Portrait Gallery. The appalling doppelgänger presents himself to Brydon in the tale, as though he were a portrait.

> So Brydon before him took him in; with every fact of him now, in the higher light, hard and acute – his planted stillness, his vivid truth, his grizzled bent head and white masking hands, his queer actuality of evening dress, of dangling double eyeglass, of gleaming silk lappet and white linen, of pearl button and gold watchguard and polished shoe. No portrait by a great modern master could have presented him with more

intensity, thrust him out of his frame with more art, as if there had been 'treatment' of the consummate sort, in his every shade and salience.

James's word 'treatment' corresponds to Ford's 'rendering'. The critic Viola Hopkins made the intelligent observation that the physical description of the phantom resembles James's own description of some of Sargent's powerful portraits of American businessmen. Having established the solidity of specification of the physical presence, James goes on to describe the violence and opposition of this alternative version.

Such an identity fitted his at *no* point, made its alternative monstrous. A thousand times yes, as it came upon him nearer now, quite as one of those expanding fantastic images projected by the magic-lantern of childhood; for the stranger, whoever he might be, evil, odious, blatant, vulgar, had advanced as for aggression, and he knew himself give ground. Then, harder pressed still, sick with the force of his shock and falling back as under the hot breath and the roused passion of a life larger than his own, a rage of personality before which his own collapsed, he felt the whole vision turn to darkness and his very feet give way. His head went round; he was going; he had gone.

The amalgamation of original and image, here, the struggle for survival in a space that can hold only one of the two, is conveyed in the syntax, in the way the feeling shifts between phrases from the 'subject' of the sentence and the advancing rage of personality of the 'alternative'. Portraits which, in the psychological exploration of a Proust or a Zola, are outcrops of the minds, the ideas, the bodies, the erotic curiosity, of sitter and painter, become in Wilde's and James's stories detached demonic forces, loose in the world and uncontrollable.

One of the most complete and credible painters in fiction is of course Joyce Cary's Gulley Jimson in *The Horse's Mouth*. He is part of an intricate fictive portrait of Sara Monday, which is constructed in three separate first-person narratives, each of which is also a self-portrait of the narrator. The first voice, in *Herself Surprised*, is Sara's own, naïve and cunning, sexy and practical. The second, in *To Be a Pilgrim*, is Tom Wilcher, a rich man, whose preoccupations are political and religious, whose conduct is noble and unscrupulous by turns, who is a puritan and a dirty old molester of girls, who deceives himself and sees some things clearly. The third is Gulley Jimson,

obsessive artist, Blake-quoter, thief, wife-beater, down-and-out. The worlds of the three tales are both closed and coherent in themselves – all three narrators *notice* different things, as well as giving different accounts and explanations of overlapping events. The experience of reading them is rather like that of understanding the idiosyncrasies of one's own language better for having learned another. Or seeing portraits of the same woman, or group, by three different artists, with different arabesques and ways of rendering reality. Jimson's narrative is full of colour-painterly descriptions of skies and flesh, brilliant writing about the act of painting, a wonderful bravura display of the perpetual recomposition of the visual world into artwork. Here, as an example, is the arm of the angry and respectable spinster, Coker, seen whilst she sleeps.

And what a forearm. Marble in the moon. Muscled like an Angelo, but still a woman's. Nothing obvious. Modelling like a violin solo. The sweetest elbow I ever saw, and that's a difficult joint. No fat above the wrist but a smooth fall into the metacarpals. Just enough structure to give the life and the power. Bless the girl, I thought, she's a beauty and doesn't know it. I could have kissed Coker for that elbow. But what would be the

Paul Cezanne, *The Eternal Female*

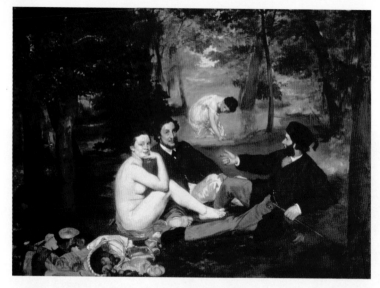

Edouard Manet, *Dejeuner sur l'Herbe*

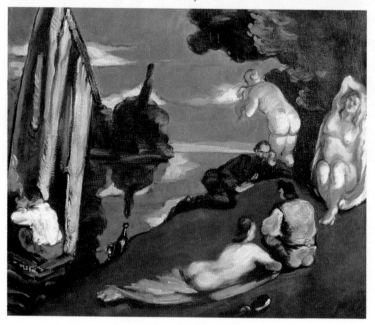

Paul Cezanne, *The Idyll (Pastorale)*

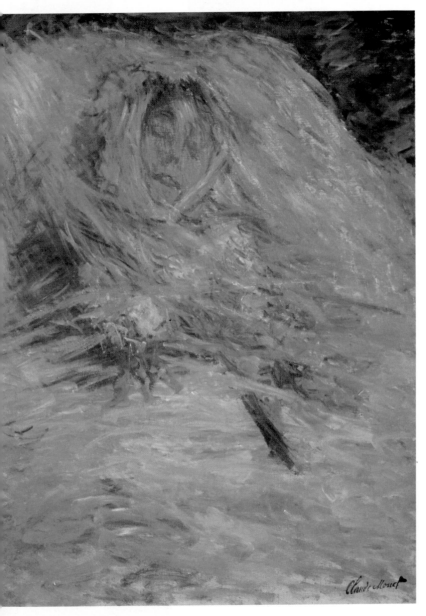

Claude Monet, *Camille Monet on her deathbed*

Ivan Albright, *Picture of Dorian Gray*

John Singer Sargent,
Asher Wertheimer

John Bratby, *Adam and Eve*,
from *The Horse's Mouth* series, 1958

Matthew Smith,
Standing Nude with Fan

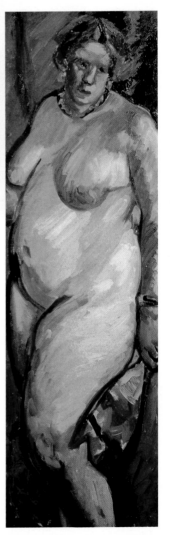

Edouard Vuillard, *The Manicure*

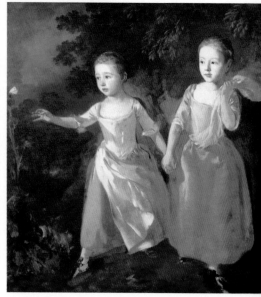

Thomas Gainsborough,
*The Painter's Daughters
Chasing a Butterfly*

good of that? She wouldn't believe me if I told her an
elbow like that was a stroke of genius.

And I thought, that's the forearm I want for Eve,
with Sara's body. Sara as she was about thirty years ago.
Sara's forearms were always too soft. Cook's arms.
Mottled brown. Greedy and sentimental arms. Lustful
wrists crested like stallions with venus rings. But Eve
was a worker. The woman was for hard graft. Adam the
gardener, the poet, the hunter. All wires like a stringed
instrument. Nervous fibre. Eve smooth and thick as a
column, strong as a tree. Brown as earth, or red like
Devon ground. Red would be better. Iron ground. Iron
for the magnetic of love. English Eve.

This is not the best example of Cary's brilliant
rendering of Gulley Jimson's thought processes. He
keeps it up, restlessly and brilliantly, through the whole
novel, scattering ingenious metaphors and analogies,
all seen in terms of the subsequent shaping of an
artwork. I chose this passage partly because it is
comparable with Claude Lantier seeing Christine and
her flesh as an object, partly because it shows the
thought processes of an artist combining two originals
into one portrait, and knowing exactly how it will be
done, and why. It is also comparable to Proust's
narrator, deciphering the visual metaphors and links of
form in Miss Sacripant. And especially interesting,

perhaps, is the way emotional adjectives, in Jimson's vocabulary, connect quite naturally to, inhere in, visual forms, 'Greedy and sentimental arms', 'Lustful wrists'. Jimson's subjective interpretation – Wilcher sees Sara quite differently – is what he will make solid in his portraits.

Throughout this novel Cary makes his readers *see* his paintings with extraordinary clarity and sufficiency of inward imagery. This makes the excellent film, made from the book in 1958, problematic for readers. The artist, John Bratby, was commissioned to paint Gulley's paintings for the film, and those paintings have a very vigorous pattern of identifiable gestures, recognisable as Bratby's. Once anyone has seen the film, he or she cannot imagine Jimson's paintings as other than Bratby's – which are an image, a portrait, of the mind of Bratby, not of Cary, or of Jimson. Or, more justly, they are an image of Bratby's imagination of the imagery of Jimson and through Jimson, Cary. If we consider other Bratbys, we can see the way in which Bratby–Jimson is Bratby. The problem is greater than the problem with the existence of the film version of the picture of Dorian Gray. It is a great hindrance to doing the proper work of the imagination when reading Cary. It is helped by

looking at other paintings of the period – Matthew Smith perhaps – creating a different set of signs, emphases, references.

It is Gulley Jimson's attempt to steal his old nude studies of Sara, that leads to her death. But the descriptions are full of energy and life.

A portrait – many portraits – are at the centre of Salman Rushdie's *The Moor's Last Sigh*, in which painted portraits carry riddling messages about guilt and heredity as well as art. Rushdie introduces another version of the idea of the painting standing outside, or resisting time. His hero-narrator has a disease that causes him to age prematurely – far from being eternally young, he rushes towards premature senility and death. His mother, Aurora Zogoiby, paints him over and over as 'The Moor', recording his ageing, incorporating him into myth and legend in many forms. When the portrait-painter is also the mother, the model is both her creation and its reproduction. Her 'last, unfinished, unsigned masterpiece "The Moor's Last Sigh"' contained, her son tells us, a concealed prophecy of her death. It depicts 'the moment of Boabdil's expulsion from Granada' and 'had been stripped to

the harsh essentials, all its elements converging on the face at its heart, the Sultan's face, from which horror, weakness, loss and pain poured like darkness itself, a face in a condition of existential torment reminiscent of Edvard Munch . . .'

As I set down my memories of my part in those paintings, I am naturally conscious that those who submit themselves as the models upon whom a work of art is made can offer, at best, a subjective, often wounded, sometimes spiteful wrong-side-of-the-canvas version of the finished work. What then can the humble clay usefully say about the hands that moulded it? Perhaps simply this: *that I was there*. And that during the years of sitting I made a kind of portrait of her, too. She was looking at me, and I was looking right back.

In the final Gothic sequence of the novel, a thieving, mad, rich man, who was Aurora's lover, takes Zogoiby prisoner and shows him the X-rays of *The Moor's Last Sigh*, which reveal the murderer painted underneath. He turns out to be Zogoiby's father. Zogoiby is chained in a room with a Japanese woman picture restorer, also chained, who is revealing the buried form of a woman, a self-portrait as an archetypal bare-breasted childless madonna, under another portrait of

the Moor. Vasco, the madman, threatens them with a revolver.

> Aoi screamed and ran uselessly across the room. There was a moment when her upper half was hidden by the painting. Vasco fired, once. A hole appeared in the canvas, over Aurora's heart; but it was Aoi Uë's breast that had been pierced. She fell heavily against the easel, clutching at it; and for an instant – picture this – her blood pumped through the wound in my mother's chest. Then the portrait fell forward, its top right-hand corner hitting the floor, and somersaulted to lie face upwards, stained with Aoi's blood. Aoi Uë, however, lay face downwards, and was still.
>
> The painting had been damaged. The woman had been killed.

This is a final ghastly image of the portrait, as in the tale of Pygmalion, coming to life, no longer a 'face without a heart' for the picture restorer's heart is behind the pictured woman who herself is behind the painted Moor. For it comes to life only to become bloodstained with death, a wild version of the blood that is there to desert the cheeks of Dorian Gray's ageing portrait. Vasco then dies – he is pumped full of heroin – and Zogoiby remarks that he has had a mythic needle in his arm, the splinter of ice left by his

Bhupen Khakar, *Salman Rushdie*

encounter with 'the Snow Queen, my mother, whom he had loved, and who had made him mad'. Vasco's life-blood also 'darkens' the canvas. In the Hans Andersen story from which Rushdie takes the Snow Queen reference, the fatal splinter which goes into Kay's eye is not ice, but a fragment of a magic, distorting mirror made by an enchanter, stolen and broken into fragments, which fell to earth from the air. Mirrors freeze. Portraits become mirrors, become preserving ice, which arrests life in a semblance of death. Aurora makes distorting mirrors in her obsessive works of art. The images in all the reflections do not speak.

When Bhupen Khakhar painted his portrait *Salman Rushdie: The Moor* in 1975 he echoed this fusion and distortion, combining the elements of Western and Mughal painting with scenes from the navel.

A very recent example of an unusual fiction about portraits is David Ebershoff's *The Danish Girl*, whose plot concerns a Danish painter married to an American woman painter. She asks him to pose for her in a dress so that she can get on with a portrait in the sitter's absence. Wearing the dress makes the man realise slowly that he wishes to be, is, a woman. He ends up by

becoming the painted woman – Lili instead of Einar –
from time to time, and then permanently. The story is
mostly delicately and precisely told, the characters
unexpected in their resourcefulness and their anxieties
in this situation. Einar feels that the covering of silk is
the overlaid skin of another self (as a painting is a skin
over the surface of the canvas, two textures, one
image).

> Einar could only concentrate on the silk dressing his
> skin as if it was a bandage. Yes, that was how it felt the
> first time: the silk was so fine and airy that it felt like a
> gauze – a balm-soaked gauze lying delicately on healing
> skin. Even the embarrassment of standing before his
> wife began no longer to matter, for she was busy
> painting with a foreign intensity in her face. Einar was
> beginning to enter a shadowy world of dreams where
> Anna's dress could belong to anyone, even to him.

This is a very odd version of the Pygmalion story. The
couple love each other, and Greta, the American, with
good will and good sense, makes friends with Lili and
paints her. She exhibits a whole series of Lili paintings,
which are an enormous success. There is

> Lili Thrice – 'three views of a girl's head at full scale: a
> girl removed in thought, her eyelids tired and red; a girl

Ali Campbell, *Male/female*,
used on the jacket of David Ebershoff's *The Danish Girl*

Gerda Wegener, *A Parisian at Carnival – Einar Wegenar*

white with fear, her cheeks hollow; a girl over-excited,
her hair slipping from its clip, her lip dewy'.

There is a glowing response to this painting in a Paris
review. '"A wild and rhapsodic imagination," it said of
Greta. "Her painting of a young girl named Lili would
be frightening if it wasn't so beautiful."'

For Greta, the portraits are a way of discovering the
woman Einar has become; for Einar they are mirrors in
which that identity is reflected. His own painting
receives less and less attention. He is unbothered. It is
a new twist on the idea that the portrait transfigures the
sitter. The story is based on a true story, the story of
the man on whom the first sex-change operation was
performed. The portrait exists.

For Einar and Greta, portraits are self-discovery,
self redefinition. For Iris Murdoch, novelist and
philosopher, portraits at their highest were, like all
works of art, an attempt to tell the truth, however
difficult the work of telling, however partial the truths
told. *The Sandcastle*, her third novel, is not one of her
best. It is about a middle-aged schoolmaster who falls
helplessly in love with a young portrait painter called
Rain, who has come to the school to paint a valedictory
portrait of the headmaster, Demoyte. Iris Murdoch

believed strongly in T.S. Eliot's idea of the imper-
sonality of the artist, in the expunging of the self, and
its fantasies and desires, from the rendering of the real
world. In *The Sandcastle* her ideas about art in general
are worked out through dialogues and thoughts about
the particularity of portraits.

When I first read this novel it was those ideas that
interested me most in it, not the doomed love affair,
however good Murdoch is at depicting human
beings in the clutches of passion. I admired Murdoch
when I first read her for her powers of invention, a
sense that she could make things up, in intricate
forms, which were precisely not self-revelation, nor
self-expression, nor self-analysis. I now think, with
belated hindsight, that Rain in *The Sandcastle* is the
nearest Murdoch ever came to a traditional youthful
self-portrait, a slightly idealised clever girl, a little
daring, with Murdoch's face and haircut, given to
wearing trousers when that was shocking, or at least
startling, in women. I also think that some kind of
personal emotion, some effort to disguise both the
story and the feelings of the characters, is what
makes the novel in a sense a second-rate novel. But
here is a youngish novelist working out the ethics of
portrait painting as an analogon to her own craft.

'Every portrait is a self-portrait,' said Rain. 'In portraying you, I portray myself.'

'Spiritual nonsense,' said Demoyte. 'I want to see your flesh, not your soul.'

'Artists do paint themselves in their sitters,' said Rain. 'Often in quite material ways. Burne-Jones made all his people look thin and gloomy, like himself. Romney always reproduced his own nose, Van Dyck his own hands . . .'

'I don't know,' said Rain, 'whether it shows a limitation, if we want to see ourselves in the world about us. Perhaps it is rather that we *feel* our own face, as a three-dimensional mass, from within – and when we try in a painting to realise what another person's face *is*, we come back to the experience of our own.'

'You think we feel our faces as if they were masks?'

Murdoch, like Proust, is genuinely interested in the rhythms of paint as opposed to language. She gives a painterly description of the imaginary portrait of Demoyte, who is a collector of shimmering gold Afghan rugs. I see her work in my mind as somewhere between Vuillard and Bonnard, both of whom Murdoch admired and loved. It is interesting, for another writer, to wonder how exact was Murdoch's mental image of the ghost of this imaginary painting, which she enables us to map in our own minds. Writing

such descriptions, I find, calls features into being in a kind of unvisualised visual pattern, but it may not be the same for all writers. I can 'see' Demoyte's lips, nose and eyes, and the overall colour of the painting, but I do not think I really 'see' them well enough to copy my image on to paper, even if I could paint, which I can't. And yet it is a precise image, it has a solidity. This is the moment when it comes together in Rain's mind. Murdoch once said that every artist both longs for and dreads the moment when a work settles into its form, which cannot then be changed.

What Rain had lacked was the motif of the pattern. But this had lately occurred to her, and with it came the definitive version, which she had been seeking, of Demoyte's face. The old man's face, it now seemed to her, was of a withered golden colour, like an old apple, and marked with the repetition of a certain curve. Supremely this curve occurred in his lips, which Rain proposed to paint curling in a slightly sarcastic to amused manner which was highly characteristic of him. It appeared again, more subdued, in his eyebrows, which met bushily above his nose, and in the line made by his eyes and the deep wrinkles which led upwards from their corners. The multitudinous furrows of the forehead presented the same motif, tiny and now endlessly repeated, where the amusement was merged

into tolerance and the sarcasm into sadness. Rain had chosen as part of the background one of the rugs which, as it seemed to her, spoke the theme again. In some obscure way this patterned surface continued to be expressive of the character of the sitter, with his passionate interest in all-over decoration. Rain selected a noble Shiráz of a more intense golden shade, not unlike the colour in which she proposed to paint the old man's face, and wherein the curve occurred again, formalized into a more recurrent flower.

Rain sees this scheme as in danger of too much 'sweetness' and thinks about balancing it with heavy masses. Interesting here is the combination of the formal, geometric description of the repeated curve, with the brief use of emotive words – 'sarcastic', 'amused'. They shift the reader's interest from making an internal image of the pattern to the feeling of the whole face, which the pattern portrays.

Another character who is concerned with truth in painting is Bledyard, the art history master, who gives a lecture that is almost a Kingsley Amis comic set-piece – with wrong-way-up portraits of the queen, and the internal organs of a frog. His lecture (plausibly, in honour of Rain's presence at the school) is about portraits. He distinguishes various possible relations

between painter and sitter. He shows a slide of *The Laughing Cavalier*.

> 'If we ask what is the bond here that holds the sitter the sitter [*sic*, Bledyard has a speech defect] and the painter together the answer is – charm. The sitter wishes to be depicted as charming, and the painter obliges him without difficulty.'

He goes on to the mosaic portrait of the Emperor Theodoric in Ravenna. 'Not a portrait of an individual by an individual, but an abstract conception of power and magnificence contained in the form of a man.' And finally, he comes to 'one of the later self-portraits of Rembrandt'.

> 'Now here,' said Bledyard, 'if we ask what relates the painter to the sitter, if we ask what the painter is after, it is difficult to avoid answering – the truth.'
> . . . The enormous Socratic head of the aged Rembrandt, swathed in a rather dirty-looking cloth, emerged in light and shade from the screen. At the edge of the lighted area, Bledyard could be seen regarding it.

This respect for truth, and the sense that the idea of truth-telling is meaningful, are very much Murdoch's own. Both in her fiction, and in her essays, she wrote

powerfully about the importance of the idea that something other than ourselves is real, the 'hard idea of truth' as opposed to the 'facile idea of sincerity'. Portraits represent the otherness of the other, apprehended and comprehended. Bledyard is almost the priest of this idea. Earlier in the novel he declares

> Who is worthy to understand another person?. . .
> Upon an ordinary material thing we can look with reverence, wondering simply at its being. But when we look upon a human face, we interpret it by what we are ourselves . . .

Rain replies, 'Our portraits are a judgement upon ourselves. I know in what way, and how deplorably, my own paintings show what I am . . .'

Bledyard says, 'It is a fact that we cannot really observe our betters. Vice and peculiarities are easy to portray. But who can look reverently enough upon another human face? The true portrait-painter should be a saint and saints have other things to do than to paint portraits.'

He goes on to say religious painters understand this, and that the figures of Christ they paint are 'not usually presented as though they were an individual'. When Caravaggio does individualise Christ, as in the

Supper at Emmaus, 'we are shocked. We should be equally shocked at any representation of a human face.' Rain Carter protests at this – she says his ideas are too 'abstract' – a failing of many of Murdoch's religious thinkers. Bledyard is profound and absurd. But the impulsive and sensual Dora in *The Bell*, fleeing the intensities and abstractions of a religious community (as well as a manipulative husband), finds herself in the National Gallery and has a credible and moving religious experience of a kind, looking at Gainsborough's painting of his two daughters.

> These children step through a wood hand in hand, their garments shimmering, their eyes serious and dark, their two pale heads, round full buds, like yet unlike.
>
> Dora was always moved by the pictures. Today she was moved but in a new way. She marvelled, with a kind of gratitude, that they were all still here, and her heart was filled with love for the pictures, their authority, their marvellous generosity, their splendour. It occurred to her that here at last was something real and something perfect. Who had said that, about perfection and reality being in the same place? Here was something which her consciousness could not wretchedly devour, and by making it part of her fantasy make it worthless . . . The pictures were something real outside herself, which spoke to her kindly

and yet in sovereign tones, something superior and good whose presence destroyed the dreary trance-like solipsism of her earlier mood. When the world had seemed to be subjective it had seemed to be without interest or value. But now there was something else in it after all.

I began by writing about the portrait of Elizabeth I and my own use of its iconic qualities in *The Virgin in the Garden*. I'd like to end with the group of portraits of Randolph Henry Ash, assembled by Roland Michell, in *Possession*. *Possession* is a novel about what biography does not reveal. Roland's collection does not add up to a coherent knowable 'character'.

Roland possessed three images of Randolph Henry Ash. One, a photograph of the death mask, which was one of the central pieces in the Stant Collection of Harmony City, stood on his desk. There was a puzzle about how this bleak-browed, carved head had come into existence, since there also existed a photograph of the poet in his last sleep, still patriarchally bearded. Who had shaved him when, Roland had wondered, and Mortimer Cropper had asked in his biography, *The Great Ventriloquist*, without finding an answer. His other two portraits were photographic copies, made to order, of the two portraits of Ash in the National Portrait Gallery ... One was by Manet and one was by G.F. Watts. The

Manet had been painted when the painter was in
England in 1867, and had something in common with his
portrait of Zola . . . Manet's Ash was dark, powerful,
with deepset eyes under a strong brow, a vigorous
beard, and a look of confident private amusement . . .
The portrait by Watts was mistier and less authoritative.
It had been painted in 1876 and showed an older and
more ethereal poet, his head rising, as is common with
Watts's portraits, from a vague dark column of a body
into a spiritual light.

I assembled this proliferation of images, half-
deliberately, to demonstrate how unsettled and partial
is our image of the dead, depending on what little
evidence we have. The death-mask and the photo-
graphed corpse are in a sense 'taken from the life' –
using the same ambivalence in the phrase 'taken from'
that appears in the translation of *Nature Morte* into
Still Life. They are accurate records – it pleased me to
make them contradictory – but only of an absence.
There is a sense in which all photographs are death-
masks, as Roland Barthes said so elegantly in his
Camera Lucida. They show the death of the moment,
if not of the human being who is taken, or caught, by
the camera. The painted portraits are also, as I have
said, images of their painters. My imaginary Manet

contains a composed array of depicted objects, as Manet's real Zola contained prints, screen and books. The objects are extensions of the self of the sitter, part of the image of him. In Ash's case they are very carefully delineated.

> There was a heap of rough geological specimens, including two almost spherical stones, a little like cannon balls, one black and one a sulphurous yellow, some ammonites and trilobites, a large crystal ball, a green glass inkwell, the articulated skeleton of a cat, a heap of books, two of which could be seen to be the *Divina Commedia* and *Faust*, and an hourglass in a wooden frame . . .

By contrast, the description of the Watts concentrates on a metaphor in the paint.

> The important features of this image were the eyes, which were large and gleaming, and the beard, a riverful of silvers and creams, whites and blue-greys, resembling da Vinci's turbulences, the apparent source of light. Even in the photograph [a black and white photograph of the original painting] it shone.

What a novelist can do, which is difficult for a painter, is convey what is not, and cannot, be known about a

human being. The triple portrait of Lili, in David Ebershoff's *The Danish Girl*, represents a painter's way of suggesting the variety of selves that can be recorded. But the painter, in a triptych or a series, remains constant – as Picasso is Picasso however many artists and models he can conceive and render. The death-mask, the Watts and the Manet suggest different things. They have what James required in a good renderer, solidity of specification – the colours are precise, the textures are there, even the expressions. But readers will see as many Manets, as many Watts, as many imaginary photographs as there are readers, all connected, all different, as I said about my imaginary woman in a green dress at the beginning. For this reason – the energy which is generated by the visualised unseen, and the further energy that springs from trying to bridge gaps and reconcile or connect discrepancies in limited descriptions – a novelist, particularly a visually minded novelist, will always feel anxious, even afraid, about the portrayal of their characters by actors. In a way, an actor whose appearance is an almost perfect match for the imagined face is more uncanny and more disturbing than one who is no match and can be peeled away in the imagination. The closer the match, the harder it is to

remember, to re-create in the mind, those aspects of the character's face and manners which don't coincide, or are deliberately written fluctuating and vague. A playwright will need to leave his characters open to a multitude of inhabitants, not to make their bodies precise, though Shaw always did, in his novelist's stage directions. Visual images are stronger than verbal half-images, and a good novel exploits the richness of the imprecision, of the hinted. Painting, as Patrick Heron said, is a materialist art, about the material world. The novel, however it aspires to the specificity of Zola's naturalism, works inside the head.

At the almost end of *Possession* Roland reconsiders his collection of portraits of Ash. He has a thought about the ambiguity of the mask which I took from one of Richard Gregory's visual riddles about whether a hollow mask protrudes or recedes. He thinks also about the poet's words, which in the case of real writers are their real selves, as much as, more than, their skin and eyes. He thinks about how the images we see, the painters who made them, are part also of those who see and read. My imaginary Manet, my imaginary Watts, my imaginary poets, are part of Roland, and they are all of course part of me.

Over his desk the little print of the photograph of
Randolph Ash's death mask was ambiguous. You could
read it either way; as though you were looking into a
hollow mould, as though the planes of the cheeks and
forehead, the blank eyes and the broad brow were
sculpted and looking out. You were inside – behind
those closed eyes like an actor, masked: you were
outside, looking at closure, if not finality. The
frontispiece of his book was a photograph of Ash on his
death-bed, the abundant white hair, the look of fatigue
caught at a transient moment between the semblance of
life and the set of death. These dead men, and Manet's
wary, intelligent sensualist and Watts's prophet were all
one – though also they were Manet and Watts – and the
words too were one, the tree, the woman, the water, the
grass, the snake, the tree and the golden apples. He had
always seen these aspects as part of himself, Roland
Michell, he had lived with them. He remembered
talking to Maud about modern theories of the
incoherent self which was made up of conflicting
systems of beliefs, desires, languages and molecules. All
and none of these were Ash and yet he knew, if he did
not encompass, Ash.

Acknowledgments

This book originated in the Fourth Heywood Hill Lecture, given at the National Portrait Gallery on 23 May, 2000. I would like to thank the Directors of G. Heywood Hill Ltd, especially John Saumarez Smith and the Duke of Devonshire, and also the National Portrait Gallery and the Director, Charles Saumarez Smith. Thanks are also due to the picture researcher for the lecture, Carrie Haines; to Gill Marsden; to Jenny Uglow and Alison Samuel at Chatto & Windus; to Gillian Catto of the Catto Gallery; and to Tom Stoppard for his help with translation. Finally, I am grateful to all the institutions and individuals, as named in the list of illustrations, who have kindly granted permission to reproduce the illustrations in the plate sections and in the text.

Index